SALT, SWORD, AND CROZIER

Thorus
immacu
latus
Hebr. 13

Iudicium
æquum
Levit. 2.

Rectores
Ecclesiæ
Eccl. 13

Regale
Sacerdo-
tium
1. P. 2

Stipen
dia pecca
ti.
Rom. 6.

NON DIMOVEBOR AB ALTO

SALT, SWORD, AND CROZIER

Books *and* Coins *from* the Prince-Bishopric *of* Salzburg
(c.1500–c.1800)

FELICE LIFSHITZ AND JOSEPH F. PATROUCH

Bruce Peel Special Collections, University of Alberta

UNIVERSITY OF ALBERTA
BRUCE PEEL SPECIAL COLLECTIONS

UNIVERSITY OF ALBERTA
WIRTH INSTITUTE FOR AUSTRIAN
AND CENTRAL EUROPEAN STUDIES

Copyright © University of Alberta Libraries 2017

All rights reserved. The use of any part of this publication—reproduced, transmitted in any form or by any means, electronic, mechanical, and recording, or otherwise, or stored in a retrieval system—without the prior consent of the publisher is an infringement of the copyright law.

Bruce Peel Special Collections
B7 Rutherford South, University of Alberta
Edmonton, Alberta, Canada T6G 2J4

LIBRARY AND ARCHIVES CANADA CATALOGUING IN PUBLICATION

Lifshitz, Felice, 1959–, author, organizer
 Salt, sword, and crozier: books and coins from the Prince-Bishopric of Salzburg (c.1500–c.1800) / Felice Lifshitz and Joseph F. Patrouch.

Catalogue of an exhibition held at Bruce Peel Special Collections, University of Alberta from September 2017 to January 2018.

ISBN 978-1-55195-377-9 (softcover)

 1. Books—Austria—Salzburg—History—Exhibitions. 2. Illustration of books—Austria—Salzburg—History—Exhibitions. 3. Manuscripts, Medieval—Austria—History—Exhibitions. 4. Coins—Austria—Salzburg—History—Exhibitions. 5. Salzburg (Austria)—Intellectual life—Exhibitions. 6. Salzburg (Austria)—History—Exhibitions. I. Patrouch, Joseph F., 1960–, author, organizer II. University of Alberta. Library, issuing body III. Bruce Peel Special Collections, host institution IV. Title.

DB879.S18L54 2017 943.6'32 C2017-903084-1

Printed in Canada.

Catalogue design: Lara Minja, Lime Design Inc.
Editorial: Cheryl Cundell
Exhibition design: Kevin Zak
Photography: Kevin Zak & Louise Asselstine
Special assistance: Linda Quirk, Jesse Carson, Robin Chorzempa, Paul Gifford, Carolyn Morgan, Jeff Papineau, Michaela Stang, Sara Tokay
Team lead: Robert Desmarais

Imprint: Bruce Peel Special Collections
First edition, first printing, 2017

{48}

CONTENTS

FOREWORD XI

INTRODUCTION	The Prince-Bishopric of Salzburg	1
ONE	The Prince-Bishop's Seminary	9
TWO	The Prince-Bishops (1519–1812)	13
THREE	The Prince-Bishop's Authority *Secular Foundations*	23
FOUR	The Prince-Bishop's Authority *Religious Foundations*	33
FIVE	Foundations *of* European Law *Ius Commune*	39
SIX	Beyond the *Ius Commune* *Selections from the Seminary Law Library (1520–1810)*	53
SEVEN	Auxiliary Sciences *Sigillography and Diplomatics*	79
EIGHT	Echoes *of* Empire *The Presence of the Past in the Salzburg Collection*	87
NINE	Controversial Contexts *The Weight of the Present in the Salzburg Collection*	97
TEN	Binding Fragments *Book Covers in the Salzburg Collection*	109

SELECT BIBLIOGRAPHY 119

ABOUT THE AUTHORS 121

THE WIRTH INSTITUTE /
ABOUT THE SALZBURG COLLECTION 123

{48}

**Ex Libris
Universitatis
Albertaensis**

UNIVERSITY OF ALBERTA
QUAECUMQUE VERA

Bibliotheca Archiepiscopalis
Salisburgensis

CANONES
ET DECRETA SA-
CROSANCTI OECVME-
NICI ET GENERALIS CON-
CILII TRIDENTINI.

SVB PAVLO III. IVLIO III.
PIO IIII. PONT. MAX.

*Opus nunc primùm in Germania excusum inte-
grè, & ad fidem autographi Romaniq́,
Exemplaris restitutum.*

ADIECTVS EST INDEX
Librorum prohibitorum, primùm ex iudicio
patrum in Concilio Tridentino delectorum,
deinde verò authoritate Pont.
Max. comprobatus.

Secunda editio & castigatior.

Anno M.D.LXV.

concil. aum desijt Aõ 1563. 4. Decem
Georgij Stadler Catechiß

FOREWORD

IN THE MID-1960s, University of Alberta history professor Helen Liebel-Weckowicz (1930–2017) helped to arrange the purchase of a substantial portion of the Archbishop of Salzburg's seminary library for the University of Alberta Libraries. This portion, now known to U of A Libraries as the Salzburg Collection, became available for purchase because Archbishop Andreas Rohrbacher (in office 1943–1969), the last titular prince-bishop of Salzburg and participant in the influential Roman Catholic reform council now known as "Vatican II" (1962–1965), was steering his archdiocese away from its medieval and early-modern, princely past. Professor Liebel-Weckowicz was able to convince the University's librarians that this was the time to take advantage of the opportunity that a Viennese antiquarian bookseller had brought to her attention and acquire approximately 3,500 volumes of the Salzburg seminary library's legal collection. It was a major acquisition, and it catapulted the University of Alberta into position to be one of the leading places in North America to study early-modern Central European law, whether it be imperial, civil, canon, or customary. The acquisition also provided one of the most significant justifications for the decision, thirty years later, to base Canada's only Austrian and Central European research and cultural unit, the Wirth Institute, at the University of Alberta.

Professor Liebel-Weckowicz followed her *coup* in 1965 with a second and even larger library acquisition a few years later when she helped the University of Alberta Libraries acquire the entire library of the Viennese Political-Juridical Reading Association. This association had been founded in the Austrian capital in the early nineteenth century, and its members played major roles in Austrian and Austro-Hungarian politics, including

in the tumultuous Revolution of 1848. With the Salzburg Collection and the Viennese Political-Juridical Reading Association Collection, the University of Alberta has a deep, rich, and diverse set of books, pamphlets, and broadsheets dating from the fifteenth into the twentieth century and dealing with a broad range of social, legal, and political issues. These two collections provide scholars and students with an avenue into Central European history that has few parallels on this continent.

This exhibition showcases books selected from the Salzburg Collection that were printed from the fifteenth through the early-nineteenth century. Titles listed in this catalogue reflect the orthography found in the books themselves. The books are supplemented by coins minted under the authority of successive archbishops beginning in the twelfth century and ending in 1786. The archbishops lost that authority in 1803 and were replaced as secular rulers by Archduke Ferdinand von Habsburg-Lorraine. A coin minted under the Archduke's authority in 1805 is the last coin shown in the exhibition. The period coins included in this exhibition are generously on loan from a private collector.

Many individuals have assisted in the conceptualization and organization of this exhibition and in the preparation of this catalogue. Thanks go to Robert Desmarais, Kevin Zak, Carolyn Morgan, Jeff Papineau, and the reading room staff of Bruce Peel Special Collections. We also give thanks to Lara Minja, Cheryl Cundell, and Grace Mehta, as well as Bernard Humpel and Thomas Mitterecker from the Archdiocesan Archive in Salzburg.

№ 4.

№ 8.

{72}

№ 5.

№ 6.

№ 13.

S. STEPHANIT S

KIL DEUS M...SE M

✠ S · GERARDI · DI · GRA · BDS · SVBOIOGVS ...

hcdaur...sus...epi

...EPI · BRIXINGN...

URBIS SALIS BVR

Salcza fl.

INTRODUCTION

The Prince-Bishopric of Salzburg

ROM THE TIME of Archbishop Eberhard II, who reigned from 1200 to 1246, until 1803, the archbishops of Salzburg were more than religious leaders. Like the popes in Rome, the archbishops ruled over substantial territories as secular princes. The exhibition title, *Salt, Sword, and Crozier*, highlights the symbols of their dual authority—the princely sword and the bishop's staff or crozier—and the basis of their economic power in their control of natural resources such as salt. The dual nature of the archbishops' authority is reflected in the commonly used term "prince-bishop." As princes, the archbishops of Salzburg ruled a territory larger than many of the duchies and other secular administrative units of the Holy Roman Empire. Salzburg's secular jurisdictions covered more territory than does the current Austrian Federal Province (*Bundesland*) of Salzburg. They extended into what are now other Austrian provinces such as Carinthia, Styria, and Tyrol, and included holdings now in Germany, Italy, and Slovenia (see map pages 6–7).

It is estimated that around 1500 as much as one sixth of the area of the empire was ruled by religious aristocracy such as the prince-bishops of Salzburg. Abbots, abbesses, and leaders of Latin Christian crusading orders similarly held joint worldly and religious positions of authority. The secular

jurisdictions ruled by these churchmen and women were represented in the Imperial Diet and were responsible for assisting in the military defence of the empire. For instance, in the late seventeenth century, Salzburg troops fought Ottoman forces besieging Vienna as well as French forces under King Louis XIV.

In their capacity as religious leaders, dating from the foundation of the diocese in the years around 700, the Salzburg archbishops exercised direct episcopal jurisdiction over a territory that stretched from north of Salzburg south across the Alps and east as far as the Hungarian border. Salzburg archbishops were granted the almost unknown privilege of appointing some of their own subsidiary bishops. They closely supervised the bishoprics of Chiemsee, Gurk, Lavant, and Seckau. They also had certain archiepiscopal privileges *vis à vis* the bishops of Freising, Passau, and Regensburg, in what is now Germany, and Bressanone, in what is now Italy. They were among the most significant of the over sixty bishops whose seats were located in the Holy Roman Empire. In addition to automatically exercising the function of Papal Legate (*Legatus natus* or "born legate"), which made them almost equal to cardinals of the Church, Salzburg's archbishops also claimed the title of *Primas Germaniae* ("Primate of Germany") from the early sixteenth century.

{1} *Matricula imperii* [*Imperial Registry*].
(Regensburg: Augustus Hanckwitz, 1695).
10.2 cm x 16.1 cm

THIS REGISTRY details the amount of taxes owed by the members of the Imperial Diet. The archbishop of Salzburg is listed with other important taxpayers, such as the elector of Bavaria, the bishop of Passau, and the abbess of Niedermünster, as well as with the city of Regensburg. Salzburg's substantial contribution was equal to that of the duchy of Bavaria, one of largest secular units of the Empire.

{2} Fridrich von Herden. *Des H. Röm. Reichs, Teutscher Nation, Grundfeste* [*The Holy Roman Empire of the German Nation, Foundations*]. (Frankfurt am Main: Georg Heinrich Oehrling, 1695).

9.7 cm x 17.2 cm

IN THE EARLY MODERN PERIOD, the Salzburg prince-bishops served as co-chairs of the Diet's second chamber, the Council of Princes, and occasionally represented the emperor himself, making the prince-bishops significant, empire-wide political figures. This edition of imperial constitutional law includes a seating chart showing where the representative of the prince-bishop was to sit during sessions of the Council of Princes. In the first chamber, the Council of Electors, sat representatives of those units charged with the election of the emperor (such as the prince-bishop of Mainz or the duke of Saxony). The third, least significant chamber consisted of representatives of the Free Cities of the empire.

Schema sub Lit. A. (zu der Grund-Veste des H. Röm. Reichs gehörig.) Ad Pag. 96.

Eigentliche und gründliche Abbildung der Sessionen auff Reichs-Tägen heutiges Tages im Fürsten-Rath.

Geistliche Banck. Reichsmarschall. Weltliche Banck.

Geistliche Banck (linke Spalte, von oben):
- Augspurg.
- Strasburg.
- Speyer.
- Eystett.
- Worms.
- Würzburg.
- Bamberg.
- Teutschmeister.
- Besanç.
- Salzburg.
- Burgund.
- Oesterreich.

c. a. a. c.

- Hildesheimb.
- Paderborn.
- Freysingen.
- Regenspurg.
- Passau.
- Trient.

Quehrbanck. Eichst. Magdeburg.

- Brixen. } a.
- Basel.
- Lüttich.
- Osnabrück. } a.
- Münster.
- Chur.
- Fulda.
- Kempten.
- Elwangen.
- Murbach.
- Luders.
- Johannit. Meister.
- Berchtolsgaden.
- Weissenburg. } c.
- Prüem. } c.
- Stabeln. } c.
- Corvey.
- Schwäb. Prälaten. } a.
- Rheinische Prälaten.

Mitte:
Salzburg. Directorial-Tisch. Oesterreich.
Secretarii.

|Secundarii und Protocollist.|
|Secund. und Protoc.|

Weltliche Banck (rechte Spalte, von oben):
- Sachs. Eisenach.
- Sachs. Gotha.
- Sachs. Weimar.
- Sachs. Altenburg.
- Sachs. Coburg.
- Pf. Lautereck.
- Pf. Zweybrück.
- Brehmen.
- Pf. Neuburg.
- Pf. Pommern.
- Pfalz Lautern.
- Bayern.

c. mit Bayern. c. mit Bayern. c. unter sich, / auch mit Bayern und Pfalz.

- Brandenb. Culmbach.
- Brandenb. Onoltzbach.
- Braunschw. Wolffenb.
- Braunschweig Zell.
- Braunsch. Grubenhagen.
- Braunschw. Calenberg.
- Halberstadt.
- Vehrden.
- 1. { Vor-Pommern. Hinter-Pommern.
- 2. { Mechelnb. Schwerin. Mechelnburg Güstro.
- 3. Würtenberg.
- 4. { Hessen-Cassel. Hessen-Darmstatt.
- 5. { Baaden-Durlach. B. Baaden. B. Hochberg.
- 6. { Sachsen-Lauenburg. Minden.

s. alternirende Häuser.

- Hollstein { Glückstadt. Gottdorff.
- Savoyen.
- Leuchtenberg.
- Anhalt.
- Henneberg.
- Schwerin.
- Ratzeburg.
- Hirschfeld.
- Nomenii.
- Mompelgard.
- Arnberg.
- Hohen Zollern.
- Eggenberg.
- Lobkowitz.
- Salm.
- Dietrichsteit.
- Nassau Hadamar.
- Piccolomini.
- Nassau Dillenburg.
- Auersberg.

Wetterauische Grafen. Schwäb. Grafen. Fränckische Grafen. Westphäl. Grafen.

Alterniren.
Competiren umb die Præcedentz.

The Prince-Bishopric *of* Salzburg and the Archdiocese *of* Salzburg

(c. 1648)

THE BOUNDARIES OF THE ARCHDIOCESE DIFFERED
FROM THOSE OF THE PRINCE-BISHOPRIC.

North Sea

Amsterdam

Netherlands

Antwerp

Brussels

Meuse River

Cologne

Rhine River

Frankfurt am Main

Trier

Mainz

Paris

Speyer

France

Seine River

Constance

Switzerland

Lake Geneva

Rhône River

Duchy of Savoy

Duchy of Milan

Principality of Piedmont

Milan

Michael J. Fisher, cartographer

{29}

ONE

The Prince-Bishop's Seminary

{3} *Canones et decreta sacrosancti oecvmenici et generalis concilii tridentini* [*Canons and Decrees of the Sacrosanct, Ecumenical, and General Tridentine Council*]. (n.p.: n.p., 1565).
9.7 cm x 16.0 cm

THE SEMINARY from which the books in this exhibition come was established during the reign of Archbishop Johann Jakob (1560–1586). Following the conclusion of the Council of Trent (1545–1563), which had legislated that bishops should erect seminaries in their dioceses to improve the education of the priests working in them, Archbishop Jakob assembled representatives from his archdiocese in March 1569. At this synod, it was

decided that a seminary should be set up in Salzburg. However, it was not until 1579 that the cathedral chapter finally authorized its establishment. The seminary appears to have become fully operational the following year. An edition of the Council of Trent's canons and decrees, open to Session 23, Chapter 18 (1563), shows the mandate to set up seminaries (see page 9). The title page of this edition is pictured on page x.

{4} Archbishop Johann Ernst. 15 *Kreuzer*. 1694. Silver. (Probszt 1848)
28 mm

THE SEMINARY was housed in various locations around the city of Salzburg over the course of its first century of operations. It was under Archbishop Johann Ernst (reigned 1687–1709), whose coat of arms is shown on this coin, that the seminary was moved to its present location. The large, new complex with the seminary and its church dedicated to the Holy Trinity was designed by the important Baroque architect Johann Bernhard Fischer von Erlach and constructed from 1694 to 1703. Most of the library collection that was not sold to the University of Alberta is still housed in the seminary, although the rarer and more valuable works in the collection have been transferred to a facility administered by the diocesan archives. Fischer von Erlach's complex has recently been renovated and houses a hotel in addition to the church and seminary.

{5} Andrés de Escobar. *Modus confitendi* [*The Way of Confessing*]. (n.p.: n.p, n.d.).
14.0 cm x 19.2 cm

APPROXIMATELY 165 BOOKS in the Peel library's Salzburg Collection were published before the opening of the seminary and were either originally in the library of the cathedral school, which predated the seminary, or acquired later by the seminary from elsewhere. The manual of confession composed by the Portuguese monk Andrés de Escobar (1348–1448) in approximately 1431 was extremely popular with clergy throughout Europe; it was published in 89 separate incunabula editions between 1455 and 1500, the period when printing technology was, metaphorically, in the cradle (the literal translation of "*incunabulum*"). It is possible that the seminary copy of the *Modus confitendi* was printed before the 1480s. If so, then it would be the oldest printed item in the Salzburg Collection.

{10}

TWO

The Prince-Bishops
1519–1812

HE FOLLOWING PAGES show coins minted by and books related to a selection of Salzburg prince-bishops from the early sixteenth century to 1803, when Prince-Bishop Hieronymus Colloredo, the last prince-bishop, resigned secular authority and released his Salzburg subjects from their legal allegiance to him.

Matthäus Lang von Wellenburg (r. 1519–1540)

{6} *Deß Hochlöblichen Ertzstifts Saltzburgk Perckhwerchs Ordnung* [*Relating to the Honorable Prince-Bishopric of Salzburg's Mining Regulations*]. (Salzburg: Hanns Bauman, 1551).

19.6 cm x 29.9 cm

HANNS BAUMAN set up the first printshop in Salzburg. This publication of mining ordinances decreed by the prince-bishop is one of the earliest books printed in the city.

{7} Archbishop Matthäus Lang. 1 *Batzen*. 1522. Silver. (Probszt 260)

25 mm

THE OBVERSE of this coin shows the archbishop's coat of arms.

Johann Jakob von Khun-Bellasy (r. 1560–1586)

{8} Feliciano Ninguarda. *Enchiridion de censvris, irregvlaritate, et privilegiatis* [Handbook of Censures, Irregularity, and the Privileged]. (Ingolstadt: David Sartori, 1583).

16.6 cm x 20.7 cm

THIS HANDBOOK includes a greeting from Archbishop Johann Jakob, founder of the seminary, to all the clergy of the archdiocese.

{9} Archbishop Johann Jakob. *1/2 Kreuzer.* 1584. Silver. (Probszt 651)

16 mm

THE OBVERSE of this coin shows the archbishop's coat of arms.

Wolf Dietrich von Raitenau (r. 1587–1612)

{10} Ambrose of Milan. *Opera* [*Works*]. Vol. 3.
(Paris: Iamet Mettayer, 1586).

26.0 cm x 40.8 cm

The cover of this book, part of a five-volume set of works of the fourth-century prelate of Milan, is embossed with the prince-bishop's coat of arms.

{11} Archbishop Wolf Dietrich. *Thaler*. n.d.
Silver. (Probszt 825)

41 mm

The obverse of this coin shows the archbishop's coat of arms.

Paris von Lodron (r. 1619–1653)

{12} Aegidius Ranbeck. *Asylon fori ecclesiastici* [*The Asylum of the Ecclesiastical Forum*]. (Salzburg: Christopher Katzenberger, 1651).
13.6 cm x 18.5 cm

THIS UNIVERSITY OF SALZBURG dissertation by Martinus Burger was supervised by Professor Ranbeck and dedicated to Archbishop Paris, founder (1622) and current namesake of the University of Salzburg (re-founded 1962).

{13} Archbishop Paris. *Thaler*. 1625. Silver. (Probszt 1199)
41 mm

ARCHBISHOP PARIS, who was particularly devoted to the Virgin Mary, had an image of the Madonna and Child included on this coin.

Maximilian Gandolf von Kuenburg (r. 1668–1687)

{14} *Ordnung, Welcher alle in dem Ertzbischthumb Saltzburg nachgesetzte Obrigkeiten in Führung der* Civil-Processen, *wie auch den* Prioritets- Gandt- Immissions –und Executions- Handlungen hinfüro nachleben sollen [Regulation which all of the Authorities Subject to the Archdiocese of Salzburg should henceforth follow in the Execution of Civil Trials, as well as Precedence, Auction, Registration, and Enforcement Actions]. (Salzburg: Johann Baptist Mayr, 1678).

14.8 cm x 19.2 cm

THIS COPY includes a handwritten greeting from Archbishop Maximilian to all the members of the civil administration of the prince-bishopric.

{15} Archbishop Maximilian Gandolf. 15 *Kreuzer*. 1686. Silver. (Probszt 1674)

27 mm

THE OBVERSE of this coin shows the archbishop's coat of arms.

Franz Anton von Harrach (r. 1709–1727)

{16} Christoph Ludwig Bluemblacher. *Tractat Von Anlait-Recht* [*Treatise on Usage Transfer Fees*]. (Salzburg: Johann Joseph Mayr, 1721).

15.0 cm x 20.5 cm

THIS TREATISE was dedicated to Archbishop Franz Anton. The dedication includes his titles as Papal Legate, Primate of Germany, and Imperial Prince.

{17} Archbishop Franz Anton. 4 *Kreuzer*. 1721. Silver. (Probszt 2046)

23 mm

THE OBVERSE of this coin shows the archbishop's coat of arms.

Sigismund III von Schrattenbach (r. 1753–1771)

{18} Gregor Zallwein. *Collectiones juris ecclesiastici novi et novissimi a decreto Gratiani usque ad nostra tempora* [Collections of New and Very New Ecclesiastical Law from Gratian's Decretum to our Times]. (Salzburg: Johann Joseph Mayr, 1760). 16.8 cm x 22.6 cm

THIS UNIVERSITY OF SALZBURG DISSERTATION by Alfons Lidl was supervised by Professor Zallwein and dedicated to Prince-Bishop Sigismund III.

{19} Archbishop Sigismund III. *Thaler*. 1759. Silver. (Probszt 2279) 39 mm

THE OBVERSE of this coin shows the archbishop's coat of arms.

Hieronymus von Colloredo (r. 1772–1812)

{20} Ignaz Thanner. *Akademischer Versuch Ueber das Vogteyrecht im Allgemeinen mit Anwendung auf das hohe Erzstift Salzburg* [*Academic Essay on the Right of Advocacy in General as Applied to the Prince-Bishopric of Salzburg*]. (Salzburg: Franz Xaver Duyle, 1794).

11.6 cm x 19.2 cm

THIS UNIVERSITY OF SALZBURG DISSERTATION was dedicated to Archbishop Hieronymus.

{21} Archbishop Hieronymus. 20 *Kreuzer*. 1775. Silver. (Probszt 2473)

28 mm

REALISTICALLY DEPICTED on this coin from early in his reign, Archbishop Hieronymus lived in exile after resigning secular authority in 1803. He died in 1812 and is buried in St. Stephen's Cathedral in Vienna.

1709

THREE

The Prince-Bishop's Authority

Secular Foundations

NE OF THE BASES for the prince-bishop's authority was economic. His office not only controlled incomes from subject peasants working holdings throughout Salzburg's secular territories but also benefitted from the substantial natural resources of the area, where ample supplies of wood and navigable waterways permitted the exploitation of various minerals and metals. Salzburg's resources included iron, gold, silver, and, of course, salt (*Salz*), which gave the city and territory their names. Salt and gold had been mined in the region for millennia, but it was only in the thirteenth century that gold and, in particular, salt mining took on major political and economic significance for the Salzburg prince-bishops. Because the demand for salt was high, and its sources were limited, the prince bishops invested heavily in the exploitation of this natural resource. Supplemented by the gold and silver mined in places such as Gastein and Rauris, Hallein's salt bankrolled the increasingly independent Salzburg prince-bishops.

The gold and silver found in the mountains near Salzburg eventually allowed the prince-bishops to take full advantage of the right to mint their own coins. They were granted minting rights and various other secular rights, including market and customs privileges, by Emperor Otto III (reigned 996–1002), but it is unclear when they began to use these rights.

By the mid-twelfth century, however, coins were being minted under their authority at their important administrative centre in Friesach in the Duchy of Carinthia on the trade route between Vienna and Venice. The so-called "Friesacher Pfennige (Friesach Pennies)," two of which are shown here (items 22 and 23), circulated throughout the southeastern reaches of the Holy Roman Empire and into Hungary and the Balkans.

2 Heller = 1 Pfennig

4 Pfennige = 1 Kreuzer

4 Kreuzer = 1 Batzen

120 Kreuzer = 1 Thaler

{22} *Pfennig.* 1164–83? Silver. (Probszt 9)

22 mm

{23} Archbishop Eberhard II. *Pfennig.* 1200–1246. Silver. (Probszt 19?)

17 mm

AFTER A PERIOD OF DISRUPTION during which the minting activity of the prince-bishops declined dramatically, Archbishop Leonhard von Keutschach (1495–1519) reorganized and reinvigorated coin production in Salzburg. The silver coins pictured were minted in Salzburg over three and a half centuries from the time of Archbishop Leonhard; they evidence the wealth of the prince-bishops during this period.

{24} Archbishop Leonhard. *Batzen*. 1500. Silver. (Probszt 99)

21 mm

{25} Archbishop Marcus Sitticus. 2 *Pfennig*. 1614. Silver. (Probzst 1009)

16 mm

{26} Archbishop Guidobald. 1/9 *Thaler*. 1666. Silver. (Probszt 1506)

26 mm x 25 mm (square)

{27} Archbishop Maximilian Gandolf. *Kreuzer*. 1681. Silver. (Probszt 1708)

15 mm

{28} Archbishop Johann Ernst. 4 *Kreuzer*. 1692. Silver. (Probszt 1855)

22 mm

{29} Archbishop Johann Ernst. 1/2 *Thaler*. 1695. Silver. (Probszt 1818)

34 mm

{30} Archbishop Johann Ernst. *Thaler*. 1709. Silver. (Probszt 1815)

41 mm

{31} Archbishop Andreas Jakob. *Pfennig*. 1748. Silver. (Probszt 2227)

12 mm

{32} *Aurea bulla Caroli IV. romanorum imperatoris* [*The Golden Bull of Charles IV Roman Emperor*]. (n.p.: n.p., n.d.).
15.0 cm x 19.8 cm

THE PRINCE-BISHOPRIC OF SALZBURG was subject to laws issued by the emperors and imperial assemblies of the Holy Roman Empire, although, like many other subsidiary jurisdictions, Salzburg enjoyed substantial autonomy. The "Golden Bull" issued by Emperor Charles IV (reigned 1346–1378) and the Imperial Diet in Metz on Christmas Day, 1356, is one of the most important constitutional documents of the empire. It is shown open to a German translation of the provisions concerning the rights of mining and minting. This edition, probably printed in the seventeenth century, is bound with other important constitutional texts such as the Peace of Westphalia (1648) ending the Thirty Years War.

{33} *Constitvtiones criminales Caroli V.* [*The Criminal Constitutions of Charles V*]. (Frankfurt am Main: Matthias Becker's Widow, 1614).

20.3 cm x 33.3 cm

THE PRINCE-BISHOPRIC OF SALZBURG accepted some aspects of imperial legislation, for example the comprehensive imperial criminal code promulgated under Emperor Charles V (reigned 1519–1556), shown in a 1614 edition. This code, often known as the "Carolina," was accepted by the imperial assembly in 1532 and by Prince-Bishop Johann Jakob for use in Salzburg in 1576. It is shown open to the legislation concerning counterfeiting. Note that someone has carefully underlined passages in this section, the only such intervention found in this entire book!

By the eighteenth century, declining production of gold and silver and increased competition from the neighbouring territories in the so-called "Salzkammergut" ruled by the Habsburg Dynasty drove the Salzburg prince-bishops increasingly into dependence on the Bavarian duchy next door for access to markets for their salt and other commodities. By the end of the century the economic bases of Salzburg's power were substantially eroded. The loss of independence for the prince-bishopric would follow.

{34} Archbishop Hieronymus. *Kreuzer.* 1786. Copper. (Probszt 2550)

23 mm

IN THIS PERIOD, copper coinage was adopted all over the Holy Roman Empire due to its convenience. In contrast to the larger copper coins shown here, the tiny silver coins previously in circulation could be easily lost.

{35} Elector Ferdinand von Habsburg-Lorraine. *Kreuzer.* 1805. Copper. (Probszt 2620)

23 mm

THE LAST RULER OF SALZBURG to exercise the right to mint coins was the ex–Grand Duke of Tuscany, Archduke Ferdinand of Habsburg-Lorraine (depicted on item 35). He was granted control of Salzburg and a few other secularized ecclesiastical properties in the Holy Roman Empire in compensation for being removed from power in Tuscany. He ruled Salzburg from 1803 to 1806. After a complicated period of transition, which saw multiple foreign occupations, Salzburg was incorporated into the Austrian Empire ruled by the Habsburg Dynasty in 1816.

{38}

FOUR

The Prince-Bishop's Authority

Religious Foundations

UST AS THE POPES highlighted their status as successors of Peter, the first bishop of the Roman church, the archbishops of Salzburg highlighted their status as successors of the two most important early bishops of the see: Rupert and Virgil. One way to underline the connection was to depict Rupert and Virgil on Salzburg coins. Rupert, who died early in the eighth century, founded the Abbey of St. Peter's in Salzburg and, according to legend, reopened the ancient local salt mines. He is normally depicted with a salt barrel. Virgil reigned as bishop from 766 to 784, having previously served as abbot of St. Peter's and reportedly built the first Salzburg cathedral (dedicated to St. Rupert). His iconographic attribute, parallel to Rupert's salt barrel, is a church building. Both appear on Salzburg coins in this catalogue: items 7, 11, 13, 15, 24 and 26 show Rupert alone, while items 4 and 29 show Rupert and Virgil together.

Peter, Rupert, and Virgil were more than historical figures. They were also venerated as saints who could miraculously protect and favour those who celebrated their memory. Peter was buried in the church of St. Peter, attached to the main papal residence in Rome, while Rupert and Virgil were buried in the Salzburg cathedral, the seat of the archbishop. The successors of Peter, and of Rupert and Virgil, thus controlled access to the sacred power emanating from the remains (relics) of their sainted

predecessors. In the seventeenth century, both the popes and the Salzburg archbishops undertook major projects to monumentalize the burial sites of their powerful saintly predecessors. Gian Lorenzo Bernini reconstructed St. Peter's Basilica and St. Peter's Square in Rome between 1656 and 1667, the culmination of centuries of building activity on the site. A new cathedral was constructed in Salzburg, according to a dramatic new design by the architect Santino Solari, between 1614 and 1628.

{36} Emmanuel Schelstrate. *Tractatvs de sensv et avctoritate decretorvm constantiensis concilii* [*Tractate on the Meaning and Authority of the Decrees of the Council of Constance*]. (Rome: Congregation for the Propagation of the Faith, 1686).
16.3 cm x 24.0 cm

THIS TRACTATE, written by the prefect of the Vatican Library, argued that the authority of the bishop of Rome was superior to that of the many prelates who had legislated limitations to papal power at the Council of Constance (1414–1418). The tractate opens with an image that underlines the saintly source of papal authority. It depicts the gospel scene in which Jesus says, "thou art Peter, and upon this rock I will build my church…. And I will give unto thee the keys to the kingdom of heaven" (Mt 16: 18–19). The engraving shows Jesus saying these words to Peter while pointing at Bernini's recently completed complex.

{37} Bartolommeo Gavanto. *Thesaurus sacrorum rituum* [*Treasury of Sacred Rites*]. (Cologne: Francis Metternich, 1734). 17.3 cm x 23.6 cm

THE FIRST TWO MONTHS of the official liturgical calendar of the Roman church included the feasts of the Chair of St. Peter in Rome (January 18) and the Purification of Mary (February 2). Despite the close relationship between Rome and Salzburg (for instance, the prince-bishop was the "born legate" of the pope), neither Rupert nor Virgil was accorded the high honour of inclusion on the Roman calendar. Originally published in 1628, the *Thesaurus* was the chief work of the Italian liturgist Gavanto (1569–1638). It was reprinted many times and considered an authoritative guide to the Roman liturgy through the end of the nineteenth century. Gavanto included tables on how to calculate the dates of moveable feasts through the year 2000.

{38} Benno Zaisperger. *Tyrocinium canonicum* [*The Canonical Novitiate*]. Vol. 1. (Freising: Johannes Christian Carolus Immel, 1721).

15.6 cm x 20.9 cm

ZAISPERGER (1684–1750) was the novice master for the community of Augustinian canons regular in Beuerberg, Bavaria; he wrote numerous textbooks for his order's novices. This frontispiece was designed by an otherwise unknown artist (J. Kendelpach) and engraved by the prolific Georg Daniel Heumann (1691–1759). The image graphically makes the novel argument that Thomas Aquinas (shown kneeling in the lower right of the engraving) was an inspired source of advice for Augustinian

canons, who normally looked to Augustine of Hippo (354–430), shown to the right of the Madonna and Child in heaven. Aquinas, a thirteenth-century Dominican friar and theologian canonized in 1323, had been granted the rare title of "Doctor of the Church" in 1667, elevating his prestige enough for Zaisperger to attempt to associate him with the Augustinians. The image also illustrates the central position in the *chorus sanctorum* ("saintly chorus") imagined for Mary, Mother of Jesus, shown in one of her most common iconographic manifestations as the Madonna with Child. Two of the Salzburg coins shown in this catalogue (items 13 and 30) also depict Mary as the Madonna with Child, as the archbishops sought to associate themselves with her sacred power.

Hieronimus **Augustinus**

Moyses

Job

Isaias

Jeremias **Ambrosius.** **Gregorius.**

FIVE

Foundations *of* European Law

Ius Commune

HE PRINCE-BISHOP and his officials functioned within the framework of the Common Law, *ius commune*, of Europe, which developed from the mid-twelfth century onwards.

The civil portion of *ius commune* was founded on a codification of Roman law sponsored by Emperor Justinian I in Constantinople (present-day Istanbul) between 529 and 534. Initially little known in the west, where Charlemagne established a rival Roman Empire in 800, it became the centrepiece of study in the civil law schools of Bologna in the mid-twelfth century. During the thirteenth century, the foundation of civil law was expanded to include an updated version of a twelfth-century Lombard treatise on feudal customs, the *Libri Feudorum* (*Book of Fiefs*). During the sixteenth century, the various portions of Justinian's codification (the *Digest*, the *Code*, the *Institutes*, and the *Novels*), in combination with the *Book of Fiefs* and other materials (such as laws of the thirteenth-century emperors Frederick II and Henry VII), came to be known as *Corpus juris civilis* ("Body of Civil Law").

The canon law portion of *ius commune* was founded on the *Concordia discordantium canonum* (*Harmony of discordant canons*), generally known as the *Decretum*, compiled at Bologna in the mid-twelfth century by Gratian, a canon law professor. The *Decretum* thematically explored and

resolved the differences of opinion among over a thousand years of papal decretals (letters), conciliar canons, and other pronouncements relevant to ecclesiastical law. The version of the *Decretum* that circulated widely in manuscript and print and that served as a valid law book in ecclesiastical courts until 1917 was not Gratian's original but rather a slightly later text compiled at Bologna, most likely by a student of Gratian. This later version incorporated many elements from Roman law, the study of which (based on Justinian) was at the time also flourishing in Bologna.

Both versions of the *Decretum* minimized papal decretals as sources of canon law. However, papal decretals became increasingly important during the late-twelfth and thirteenth centuries. In 1230, Pope Gregory IX asked his personal confessor Raymond of Penyafort (a graduate of the University of Bologna in both canon and civil law) to compile a definitive codification. This new compilation, promulgated in 1234, joined the *Decretum* at the heart of what came to be called *Corpus juris canonici* ("Body of Canon Law"). Subsequent compilations of papal decretals and other relevant materials comprised the growing "Body of Canon Law" until the sixteenth century, when full sets of these various works began to be published under that title. A massive copy of the entire *Corpus Juris Canonici*, published in Lyons in 1622, is shown in a closed state (item 39).

From the very beginning of the professionalized study of civil and canon law, legal scholars produced commentaries. The most-respected, free-standing commentary on Justinian's codification was written by Bartolo of Sassoferrato (1313–1357); a 1555 edition of his massive commentary on the *Corpus juris civilis* is shown closed (item 40). The glosses and comments of other scholars came to be incorporated into manuscript and printed versions of legal textbooks, using a standard convention for layout: the texts of the *Decretum* and the *Corpus juris civilis* were placed in a rectangle at the centre of the page, and the standard glosses to and commentaries on the text were placed in a surrounding frame. The civil law glosses developed over many centuries and incorporated new contributions well into the sixteenth century. In contrast, legal scholars in thirteenth-century Bologna effectively standardized commentaries on the *Decretum* into a "*glossa ordinaria*" or "ordinary gloss."

{39} 18.4 cm x 25.9 cm

{40} 28.2 cm x 42.2 cm

{41 & 42}

Corpus juris civilis [*Body of Civil Law*]. Vols. 3 and 5–6. (Antwerp: Philippus Nutius, 1575–1576).

SHOWN OPEN ARE TWO VOLUMES from a multi-volume set of the *Corpus juris civilis*. (The full five-volume set is also shown in a closed state. See page 46.) The image below shows a section of Justinian's *Digest*, a compilation of extracts from the works of prominent Roman jurists such as Ulpian (c.180–223) and Sextus Pomponius (mid-second century). Pages 44–45 show a section of the *Book of Fiefs*. In both cases, the legal texts are framed by extensive late medieval and early modern commentaries.

Both of these sections attracted the interest of an early-modern reader, who heavily glossed *Digest* Book XLV, "De verborum obligationibus" ("Concerning Contracts Made by Express Words"),

{41} 22.3 cm x 34.9 cm

{42} 22.3 cm x 34.9 cm

and the *Book of Fiefs*. In the latter case, the reader showed particular concern with limitations to the granting of fiefs, including the stipulation that persons who are mute cannot be invested with fiefs.

These publications testify to the complexity of the civil law tradition that prince-bishops and their agents were required to master. They sought to understand contemporary obligations with reference to ancient Roman law (as refracted through Justinian's sixth-century compilation) and medieval Lombard custom, all the while guided by a series of twelfth- through sixteenth-century comments.

Feudorum Liber primus.

vltimo vsq; ad medietatē potest, vt ṣ̄ prope. & j̄. in pluribus casibus, vel locis. verūtamē hodie in nullo istorū casuum potest vasallus sine domini volūtate id alteri cōcedere, vt in cō stitu. Fride. imperialem decet solertiā &c. si itaq; qualisqualis retentio domino prodest: vt hic, & ṣ̄. titu. j. §. si quis de manso vno. Accursius.

EPISCOPVM vel abbatem, vel abbatissam, &c.

Alias non est hic rubri. seu tit. nec litera capitalis, sed solus §. & male.

a Item si episcopus. Nullum habet vigorem. hoc qualiter sit intelligēdum, in summa exposuimus. vnde istud notandum est: quia quod constituit papa Vrbanus, in futurum dumtaxat habet locū, & merito: quia nil peccauit antiquitas, cùm huius decreti foret inscia, vt C. de testa. l. iubemus, in fi. & ff. de iure immuni. l. j. Accur.

b Non admittuntur. Sed quid si masculum relinquit & fœminam: nūquid in fœmina in feudo succeditur? Respondit non, vt j̄. titu. ij. §. ij. nisi forte masculus subito post mortē patris mortuus sit, quasi non videatur extitisse, cùm non perseuerauerit, vt ff. de iniust. rupt. test. l. postumus. nec enim patet locus fœminæ in feudi successione, donec masculus superest ex eo qui primus de eo feudo fuerit inuestitus. Infra de eo qui sibi vel su. hered. mascu. & fœmi. inue. a. c. qui sibi.

c Feudum retinere non potest. quod hic dicitur, plerisque non placet, vt in Lombard. de bene. & ter. tri. si quis terrā. Sed de quo muto sit intelligendum, quæso mihi dicas: aut enim de muto à natura: aut de muto aliàs, scilicet superueniente casu, sicut distinguitur C. qui testa. face. poss. l. discretis. de muto à natura non potest intelligi: quoniam si potuit acquirere, multo fortius debet retinere, si de alio intelligatur: sic opponitur. Quilibet in vltimo articulo vitæ mutus efficitur. Respō. peritus: amice, summam subtilitatem secutus es: igitur loquela tua à iudicibus non est admittenda, vt ff. quibus modis pign. vel hypo. solu. l. sicut. §. si debitori. imo potius est respuenda, vt C. ad Trebellia. l. penulti. & C. vt act. ab hered. & contra here. inci. l. j. & hoc quod alibi dicitur, simplicitas est amica legibus, vt institu. de fideicommiss. hered. §. sed quia. & instit. de legi. agn. succ. §. sed simplicitatem. sic ergo legitimum factum propter superuenientia turbatur, vt ff. vnde vi. l. vltima. & in authenti. de resti. & ea quæ pa. §. fina. & C. de secundis nupt. l. prima. vel intelligatur hic de feudo paterno: quod secundum quo-dam mutus, surdus, cæcus, claudus, vel aliter imperfectus nō retinebit: quia feudo seruire non valent: vt j̄. tit. an mutus vel aliter imperfect. feud. reti. c. mutus. Vel intelligas secundum quod de hac materia in summa not. in rubri. quibus modis feud. amit. §. propter casum. Accur.

DE NATVRA FEVDI.

Aliàs hic inueni notabile in glo. vacat hoc ca. propter inferius ca. mutus. sed lac. Cusredi, aliàs Columbi, hanc glo. non habet.

quæ eis subiectæ sunt, & tituli vocantur: nullū habet vigorea, secundū hoc quod cōstitutum est à papa Vrbano in sancta synodo, hoc est illud q̄ post eius decretū suerit datū: quod autē ante datum fuerit, firmiter permanere debet. Idē iuris est si sit præpositus, vel abbatissa, vel alia ecclesiastica persona quæ antiquitus nō sit solita in feudum dare: scilicet, vt quod dederit, de iure non valeat.

Fœmina posita in copula cum masculo nō succedit simul cum eo: sed ita demum si masculus non est. Baldus.

Quinetiā si quis eo tenore feudū acceperit, vt ei descēdētes masculi & fœminæ illud habere possint: relicto masculo, vlterius fœminæ nō admittuntur b. Mutus seudū retinere nō potest c, scilicet. qui nullo modo loquitur. sed si feudū fuerit magnū, quo ei ablato se exhibere non valeat: tantū ei relinqui debet, vnde se sustinere possit. Et his omnibus casibus feudū admittitur, & ad dominum reuertitur.

TITVLVS VII.
DE NATVRA FEVDI.

Non potest de comitatu, marchia vel baronia inuestitus per principem, de his pro libito deuestiri, eo quod de principe dicit, idē de maximis et maioribus valuasoribus. Baldus.

Atura feudi hæc est, vt si princeps inuestierit capitaneos suos de aliquo feudo, nō potest eos deuestire sine culpa d, id est marchiones, &

comites, & ipsos qui propriè hodie appellantur capitanei. Idē est, si inuestitura sit facta à capitaneis & maioribus valuasoribus, qui propriè hodie capitanei appellantur. Si vero facta fuerit à minoribus vel minimis valuasoribus, aliud est. Tunc enim possunt deuestiri non habita ratione culpæ: nisi fecerint hostem Romæ. tunc enim idem est in minimis, quod in maioribus valuasoribus: vel nisi emerint feudum. tunc enim precium e restituendum est secundum antiquū & rationabilem vsum. Moderni autem nō ita subtiliter cernentes, dicūt idem obseruandū in minimis quod dictū est in maioribus valuasoribus.

TITVLVS VIII.
DE SVCCESSIOne † feudi.

Si habens feudum decedat masculis & filiabus relictis: soli masculi succedūt in feudum, non filia seu fœmina. Baldus.

Sequitur de successione feudi videre. Si quis igitur decesserit filiis & filiabus superstitibus: succedunt tantum filij æqualiter f vel nepotes ex filio, loco sui patris: nulla ordinatione defuncti in feudo manente vel valente.

Feudo paterno alienato vel de quo est filia inuestita, succedit masculus superstes. Baldus.

Hoc quoq; g obseruatur, vt si frater meus alienauerit partē suā h feudi, vel fecerit inda. in vicem leg. com. capitu. j. sed domino dante ibi exponetur, & in summa etiam expositum sit.

DE SVCCESSIONE FEVDI.

Sequitur. Aequaliter. Hic colligitur in primis quòd mulieres non possunt succedere in feudo: quia masculorum conditio, quàm mulierum sicut & in tis not. vt ff. de statu hominum. l. in multis. & not. quod feud. dare possunt. §. hoc autem notandum est. quædam sunt hic notari quæ notata sunt alibi, vt in summa de successione sab intesta. est disputatum. inferius autem de successione suri plenius exponemus quæ possunt subtiliter indagari, secundum quod de hac materia in summa not.

g Hoc quoque. super istud hic glossatum inueni, vacat propter inferius cap. per successionem.

h Partem suam. id est ad libellum concesserit: quod facere potuit sine domini voluntate, vt infra de feud. capitul. primo. & hoc contingit ea ratione, quia pars ta feudi est alienata, cùm vnum erat feudum tantum, & alios fratres peruenerat ex successione patris seu aui, & donec vixerint alienator, frater eius non poterit repetere: sed alienatam secundum quod hic infra sequitur moriatur sine herede masculo, nibilo minus reuertatur ad me &c. quasi dicat, ante mortem eius non potest re-

{41 & 42}

Complete set of volumes of *Corpus juris civilis* [*Body of Civil Law*].

22.3 cm x 34.9 cm

{43} Gratian. *Decretum aureum* [*Golden Decree*].
(Paris: Udalricus Gering and Bertoldus Rembolt, 1501).

29.0 cm x 39.4 cm

{44} Gratian. *Decretum aureum* [*Golden Decree*].
(Lyons: Nicolaus de Benedictis, 1511).

15.0 cm x 22.2 cm

{45} Pope Gregory IX. *Decretales* [*Decretals*].
(Lyons: Nicolaus de Benedictis, 1510].

These two copies of the *Decretum* and the copy of the *Decretals* of Gregory IX are the oldest of the many copies of the texts held in the Salzburg Collection. All three frontispieces graphically underline the exclusively masculine nature of the figures considered as authoritative sources and authoritative exponents of canon law. Two additional copies of Gratian's *Decretum*, from 1555 and 1560, are shown in a closed state to illustrate the range of formats in which the text was published (item 46).

{46} 8.0 cm x 12.3 cm (*above*), 28.5 cm x 42.9 cm (*below*)

Johannis chappuis tumultuarium carmen.

Gratia cui nomen prebet doctissimus autor:
Propagauit opus dogmata diua gerens.
Ecclesie sancte doctores ipse citauit:
Scriptis maior vt bis sit tribuenda fides.
Diuinum quid habes: nec fallit opinio verax.
Humani non est pectoris iste liber.
Preclarum torua non spectes fronte volumen.
Lumina ne tollat sanguinolenta deus.
Irruet: et tristis medium te rumphea scindet:
Si decreta dei vis temerare pij.

Ante hec tam nitidum pressorum secula nullum
Hoc vt opus cernis, expoliere manus.
Maxima collatis reperitur epauxesis istic
Decretis: propria que bonitate carent.
Multos errores et turpes, et manifestos)
Expulit experti dextera fida viri.
Plurimus hic index doctrinas explicat omnes.
Quicquid in hoc latitat: conferet hora breuis.
Non posset liber hic fuluo mercarier auro.
Hoc perit, hic nunq deperiturus erit.

{43}

{45} 15.0 cm x 22.0 cm

Autoris geminum primo lege gramate nomen.

Inclyta pontificū legitans decreta sacroru̅.
Ocia nunc felix dulcia lector habes.
Hellespontiacis mergi deberet in vndis.
Ausus tam nitidum carpere liuor opus.
Nil facit ad tersos cumulata pecunia libros
Nulla tenet similes bibliotheca notas.
Accipuunt cornua si spectes fronte volumen:
Secula per cuncta viuito lucis egens.

Cetas sub latebras q̃ sunt viriata recōdens:
Huc oculos iuuenis porrige docte tuos.
Inops: aut trucu̅ nihil ista volumina gestāt
Deligno credas singula digna stilo.
Peruali do Zhelmine sagax, munime fultus:
Ambo peregrina conteret arma tuus.
Iamq̃ videbuntur tectis pendentia sūmis:
Sumpta tua nuper clara trypheamanu.

[Early printed page in Latin, largely illegible at this resolution. Visible headings: "Prohemium." and "Folio primo."]

SIX

Beyond the *Ius Commune*

Selections from the Seminary Law Library

1520–1810

HE SEMINARY LIBRARY had extensive holdings in all areas of law relevant to the administration of territories under the prince-bishop's jurisdiction and the care of souls in those territories: civil, canon, imperial, and customary. Representative works published over almost 300 years are shown in chronological order.

{47} Thomas Murner. *Instituten ein warer ursprung und fundament des Keiserlichen rechtens* [*Institutes: A True Origin and Foundation of Imperial Law*]. (Basel: Adam Peter von Langendorff, 1520).

15.2 cm x 20.1 cm

AN IMPERIAL POET LAUREATE, Thomas Murner (1475–c.1537) is most famous for his satirical works and his opposition to the religious reformer Martin Luther. Murner's translation of Justinian's *Institutes* is one of the oldest books in the Salzburg Collection.

{48} Justin Göbler. *Der Rechten Spiegel, auss natürlichem, den bschribnen, gaistlichen, weltlichen vnd andern gegebreulichen Rechten* [*Mirror of Laws: Relating to Natural, Written, Spiritual, Secular, and other Customary Laws*]. (Frankfurt am Main: Christian Egenolff, 1552).

19.2 cm x 31.3 cm

THE JURIST JUSTIN GÖBLER (1504–1567) is credited with having written the standard overview of the laws in force in the Holy Roman Empire in the early sixteenth century.

{49} Pope Innocent IV. *Commentaria* [*Commentary*]. (Frankfurt am Main: Sigismund Feierabendt, 1570).

22.0 cm x 36.8 cm

POPE INNOCENT IV (1243–1254), who studied law at Bologna, wrote a commentary on the *Decretals of Gregory IX* that is sometimes said to have been cited by every jurist from his immediate contemporaries through Grotius in the seventeenth century.

{50} Andreas Perneder. *Institvtiones, Außzug vnd anzaigung etlicher geschriebenen Keyserlichen vnd deß H. Römischen Reichs Rechten, wie die gegenwertiger Zeyt in Vbung gehalten werden* [*Institutes: Extract and Example of Various Written Emperor's and Imperial Law as Currently Exercised*]. (Ingolstadt: Wolffgang Eder, 1581).

20.2 cm x 32.7 cm

THE BAVARIAN DUCAL COUNCILLOR ANDREAS PERNEDER (C.1500–1543) wrote some of the most popular and practical discussions of law as exercised in the southern Holy Roman Empire. The title points to a difficult problem in Holy Roman Imperial law: the distinction between law as decreed by the Emperor and law as legislated and accepted by the collective Empire. The Salzburg Collection contains eleven books authored by Perneder, including a copy of a 1571 edition of this work.

{51} Hermann Vultejus, ed. *Commentarivs de fevdis Guerrini Pisonis Soacii, in quo definitio & distributiones feudi accurate explicantur. Accesserunt tractatus: Hieronymi Garzonii De foeminis ad feuda recipiendis vel non, et Amadei a Ponte Lombriasci, Quis sit iudex in causa feudi* [Commentary on Fiefs by Guerinus Piso Soacius, in which the definition and the distribution of fiefs are accurately explained, followed by On Whether or Not Women should Receive Fiefs by Girolamo Garzoni, and Who should be the Judge in a Case of Feudal Law by Amadeo Ponte]. (Frankfurt am Main: Johannes Collizius, 1598).

10.1 cm x 17.6 cm

VULTEJUS PUBLISHED, with his emendations and comments, three Latin works on feudal law written by Italian jurists. Ponte's treatise dated from 1577, and Soacius's commentary was a new publication in 1598. Garzoni's 1580 tractate systematically discredited the various misogynistic arguments that were commonly used to justify barring women from inheritances (such as that women cannot keep secrets) to argue in favour of female inheritance of fiefs.

{52} Benedict Carpzov. *Volumen disputationum historico-politico-juridicarum* [*A Volume of Historico-political-juridical Disputations*]. (Leipzig: Johannes Bauer, 1651).

15.8 cm x 20.0 cm

THIS COLLECTION of disputations held in Leipzig, where Carpzov (1595–1666) was a law professor, covered a range of topics such as how to construct family trees and whether a married woman's earnings belonged to her husband.

{53} *Newe peinliche Landtgerichts-Ordnung in Oesterreich unter der Ennß* [*New Criminal Code for Lower Austria*]. (Vienna: Johann Jacob Kürner, 1663).

19.2 cm x 28.4 cm

A COPY of Emperor Ferdinand III's (reigned 1637–1657) new criminal code for his hereditary land of Lower Austria, decreed in 1656.

{54} Philippus Paschalis. *De viribus patriae potestatis, tractatus amplissimus quatuor in libros distinctus, in quibus omnia, quae parentes erga liberos possint, vel debeant* [*A Very Extensive Tractate on the Force of Paternal Authority, divided into Four Books concerning all the Rights and Obligations of Parents towards their Children*]. (Jena: Samuel Krebs, 1672).

20.2 cm x 33.0 cm

THIS TREATISE covered multiple aspects of family law and answered questions such as whether a contract of donation between a father and a son could be legally valid.

{55} Jacob Ayrer the Younger. *Historischer processus juris* [*Historical Trial*]. (Frankfurt am Main: Johann Melchior Bencard, 1691).

16.9 cm x 21.5 cm

JAKOB AYRER THE YOUNGER (c.1569–c.1625) was the son of a poet from Nuremberg. This hugely popular satirical work was first published in Frankfurt in 1597. It features Satan leading a legal case against Jesus for destroying Hell and illustrates many of the ways that cases can be delayed.

{56} Johann Martin Engelhardt. *Cursus Biennalis Studii Canonici* [*A Two Year Course in Canon Law*]. (Mainz: Johann Mayer, 1700).
9.9 cm x 16.9 cm

THIS CANON LAW TEXTBOOK recorded Engelhardt's lectures at the University of Mainz. It was dedicated to the Prince-Archbishop of Mainz, patron of the university, who also served as Arch-chancellor and Elector of the Empire. The Salzburg Collection also includes a 1736 copy of the textbook (not shown in this exhibition), indicating that it was likely a valued resource for basic legal education at the seminary. Nikolaus Person (1648–1710), creator of the frontispiece engraving for the 1700 edition, was one of the most significant cartographers and architects (both civil and military) of the seventeenth century.

{57} Georg Melchior von Ludolf. *De jure foeminarum illustrium* [*On the Rights of Illustrious Women*]. (Jena: J. F. Bielckius, 1711). 16.5 cm x 20.7 cm

MELCHIOR VON LUDOLF (1667–1740) wrote this doctoral dissertation at the University of Jena. He went on to an illustrious career as a jurist attached to the *Reichskammergericht* (Imperial Chamber Court), one of the highest judicial institutions in the empire.

{58} Martin Pegie. *Juristische Ergötzlichkeiten vom Hunde-Recht, und denen darbey vorkommenden Fällen. Welchen, als ein Anhang, das Recht derer Tauben und Hüner beygefüget worden* [*Juridical Pleasantries concerning Canine Law and Related Cases, including an Appendix on the Law concerning Doves and Chickens*]. (Frankfurt am Main and Leipzig: Carl Christoph Immig, 1725).

16.2 cm x 20.5 cm

MARTIN PEGIE (1523–1592) was one of the most popular and accessible of writers on practical legal issues in the Holy Roman Empire. The Salzburg Collection contains at least seven other works by him. Originally from what is now Slovenia, he worked for the Salzburg archbishops and produced one of the foundational works in early modern astrological studies. His two works shown here (see also item 60) reveal his interest in very practical matters, ranging from marriage law to domestic animal husbandry regulation.

{59} Andreas Gail. *Tractat von Pfandungen, ingleichen auch von Arresten und Verhafftungen* [*Treatise on Pawning as well as on Arrests and Imprisonments*]. (Nuremberg: Johann Ernst Adelbulner, 1731).

15.8 cm x 20.6 cm

GAIL (1526–1587) was one of the most influential jurists of his time, particularly because he served on both the Imperial Chamber Court in Speyer and the Imperial Aulic Court in Vienna. The Salzburg Collection contains three copies, published in 1626, 1673, and 1721, of his 1578 work *Observationes practicae* (*Practical Observations*), one of the foundational works for the study of early modern imperial law. This treatise on pawning and other matters deals with more mundane aspects of the law.

{60} Martin Pegie. *Unterricht von Recht und Freyheiten derer Heyrats-Güter* [*Instruction concerning the Law and Privileges relating to Marriage Goods*]. (Frankfurt am Main and Leipzig: Franz Köngott, 1733).

16.6 cm x 21.3 cm

Herrn ANDREÆ GAILS, J. V. D.

Deß
Kayserl. Cammer-Gerichts Assessoris, Ihro
Römischen Kayserl. Majest. Rath, und Seiner Chur-
Fürstl. Durchl. zu Cölln ꝛc. ꝛc. Cantzler ꝛc.

TRACTAT
Von
Pfändungen,
ingleichen auch von

Arresten und Verhafftungen,
sonst auch
Kummer-Klagen genannt,

Von dem seel. Herrn Authore in Latein beschrieben, denen
dieser Sprach noch unerfahrnen aber, zum besten getreulich
in das Teutsche übersetzt.

Ein Werck, so jederman, absonderlich denen, die bey Ge-
richten zu schaffen haben, in specie aber denen auf dem Lande
wohnenden unentbehrlich und nützlich.

Nürnberg, zu finden bey Johann Albrecht.
Gedruckt bey Johann Ernst Adelbulner. 1732.

{59}

MARTINI PEGII, J. U. D.
Des hohen Dom-Stiffts zu Salzburg gewesenen Syndici und
nachmahls Hochfürstlichen Hof-Raths,
Vollkommener
Unterricht
von
Recht und Freyheiten
derer
Heyraths-Güter,
und aller dahin gehörigen
Bedingnüssen,
in fünff besondere Bücher abgefaßt, und aus dem
Lateinischen übersetzt.

Franckfurth und Leipzig,
bey Johann Albrecht, Buchhändler in Nürnberg, 1733.
Gedruckt bey Franz Köngott.

{60}

Erklärung
derer
Institutionum Justiniani
IV Bücher

{61} Johann Gottfried Boltz. *Deutliche Erklärung Derer Institvtionum Keysers Justiniani* [*Clear Explanation of the Institutes of Emperor Justinian*]. (Nuremberg: Endter's Daughters and Engelbrecht's Widow, 1734).

16.9 cm x 20.7 cm

ILLVSTRISSIME COMES.

{62} Antonius Schulting. *Jvrisprvdentia vetvs ante-jvstinianea*
[*Ancient Pre-Justinianic Jurisprudence*]
(Leipzig: Weidmann, 1737).
19.1 cm x 25.4 cm

ITEMS 61 AND 62 are works by Boltz (1690–1759) and Schulting (1659–1734) showing that ancient Roman law remained relevant in the eighteenth century. The (unsigned) engraving from Boltz (pages 68 and 69) shows how the court of Emperor Justinian was imagined in the early modern period, whereas the (also unsigned) engraving from Schulting (above) seeks to make a more complicated allegorical statement, the relation of which to the legal text (originally published in Leiden in 1717) remains unclear.

{63} Johann Friedrich Hertel. *Politische Thee- und Coffe-Tassen vor das delicate Mäulgen der Madame Justiz, mit der gedoppelten Zunge; oder, Juristische Streit-Fragen von denen letzten Willens-Verordnungen und Erbschafften* [Political Tea and Coffee Cups before the Delicate Mouth of Madame Justice with the Forked Tongue, or, Juridical Controversies concerning the Stipulations of Last Wills and Inheritances]. (Jena: Georg Michael Marggraf, 1743).

10.7 cm x 17.9 cm

HERTEL (1667–1743) was a jurist at the University of Jena. The Salzburg Collection also contains a second satirical work by Hertel, his *Political Snuff Box before the Wax Nose of Justice* (1739). These works do not reflect the majority of his writings, which were much more conventionally juristic.

{64} Franz Xaver Gmeiner. *Das öffentliche allgemeine Kirchenrecht nach den Grundsätzen des Naturrechtes, der Vernunftlehre, und des Staatsrechtes ... in mathematischer Lehrart verfaßet* [*Public, General Church Law following the Principles of Natural Law, Reason, and Public Law ... Composed after the Fashion of a Mathematical Textbook*]. (Frankfurt and Leipzig: Lechnerische Universitätsbuchhandlung, 1779–81). 10.2 cm x 17.5 cm

ORIGINALLY FROM SLOVENIA, Gmeiner (1752–1822), of the University of Graz, contributed to the rationalistic reorganization of the Roman Catholic Church in Austria.

{65} *Allgemeine Gerichtsordnung* [*General Court Code*].
(Vienna: Johann Thomas Edl von Trattner, 1781).
12.9 cm x 20.6 cm

THIS LEGAL CODE for all of the Austrian Habsburgs' hereditary lands (compare item 53 above) covered Bohemia, Moravia, Silesia, Upper and Lower Austria, Styria, Carinthia, Tyrol, and other holdings. It was issued by Emperor Joseph II (reigned 1765–1790). By the later eighteenth century, Salzburg was being drawn increasingly into the Austrian Habsburgs' orbit, to which it would be permanently connected a third of a century later. The blocked-out text probably referred to an outdated price.

{66} *Rechtshandel der drey Könige Ludwigs des XVI. von Frankreich-Burbon, Karl des III. von Spanien-Burbon und des Knopfmachers Georg des III. von Hanover so vor dem Tribunal der europäischen Mächte abgehandelt worden* [How the Trial of Three Kings, Louis XVI Bourbon of France, Charles III Bourbon of Spain, and the Buttonmaker George III Hanover, was Handled before the Tribunal of European Powers]. (n.p.: n.p., 1782).
9.9 cm x 16.7 cm

THIS ANONYMOUS SATIRE used a mock trial format to indict some contemporary rulers, primarily for their excessive militarism. Among the tribunal's judges were the Ottoman Sultan Abdul Hamid I, Catherine the Great of Russia, Emperor Joseph II, and Queen Maria of Portugal. The French original, published in London in 1780, was written by Ange Goudar (1720–1791), who first came to London as a French spy in 1777. Goudar's scandalous work was a great success. His German translator remains unidentified.

{67} *Allgemeines Gesetz* über *Verbrechen, und derselben Bestrafung* [*General Law on Crimes and their Punishment*]. (Vienna: Johann Thomas Edl von Trattner, 1787).

11.9 cm x 20.1 cm

EMPEROR JOSEPH II's general criminal law code highlights the practical bent of his legislative priorities. For example, this publication provides a convenient template for recording the names, crimes, dates of arrest, and punishments of criminals.

{68} Christian Daniel Erhard, ed. *Handelsgesetzbuch. Nach der Französischen Originalsausgabe verdeutscht* [*Commercial Law Book. Translated into German from the Original French Edition*]. (Dessau and Leipzig: Georg Voß, 1808).

11.4 cm x 20.1 cm

{69} Anton Michl. *Kirchenrecht für Katholiken und Protestanten mit Hinsicht auf den Code Napoleon und die baierischen Landesgeseze* [*Church Law for Catholics and Protestants with Reference to the Napoleonic Code and the Bavarian Laws*]. (Munich: Joseph Lentner, 1809).

12.2 cm x 20.6 cm

{70} *Code pénal* [*Penal Code*]. (Paris: Garnéry, 1810).

12.3 cm x 19.9 cm

THESE THREE BOOKS show the changing legal landscape of Salzburg as its independence ended and before its incorporation into the new Austrian Empire. After Prince-Bishop Colloredo signed his resignation as secular ruler in 1803, the territory of the former prince-bishopric changed hands repeatedly. French troops had already occupied Salzburg briefly in the winter of 1800 to 1801 and were back in the winter of 1805 to 1806. Their ally Bavaria received Salzburg in the Peace of Schönbrunn in 1809 and retained control over it until a negotiated settlement with Austria in 1816, which resulted in Austria permanently gaining the territory.

Napoleons I
Kaysers der Franzosen, Königs von Italien und Protectors des Rheinbundes

Handelsgesetzbuch

Nach
der Französischen Originalausgabe verdeutscht
mit einer Einleitung und einigen erklärenden Anmerkungen
auch einem vollständigen Sachregister

herausgegeben
von

D. Christian Daniel Erhard

Königlich Sächsischem Oberhofgerichtsassessor, ordentlichem Professor der
Rechte auf der Universität Leipzig, des Landgerichts im Markgrafthum
Niederlausitz und der Leipziger Juristenfacultät Beysitzer, der Russisch.
Kaiserl. Gesetzcommission Correspondenten, der Erfurter Akademie der
Wissenschaften, der Warschauer und Oberlausitzer gelehrten Gesellschaften
und der Leipziger deutschen Gesellschaft Mitgliede.

Mit Königl. Sächs. Privilegium.

Dessau und Leipzig,
bey Georg Voß.
1808.

{68}

Kirchenrecht
für
Katholiken und Protestanten
mit Hinsicht
auf den
Code Napoleon
und die
baierischen Landesgeseze
verfasst
von
Anton Michl,
Königlich baierischem geistlichen Rathe und öffentlichem
Lehrer des Kirchenrechts und der Kirchengeschichte an
der Ludwig - Maximilians - Universität in Landshut.

München,
bei Joseph Lentner.
1809.

{69}

{70}

CODE PÉNAL,

ÉDITION

CONFORME A L'ÉDITION ORIGINALE DU BULLETIN DES LOIS ;

PRÉCÉDÉ

De l'Exposé des Motifs par les Orateurs du Conseil d'État, sur
chacune des lois qui composent ce Code, avec une Table
alphabétique des Matières.

PARIS,
GARNÉRY, LIBRAIRE, RUE DE SEINE.

DE L'IMPRIMERIE STÉRÉOTYPE DE MAME, FRÈRES.
M. DCCCX.

TAB. VIII.

No. 1. ✠ CVNRADVS · II · ROMANORV · REX · DI · GR·

No. 2. ✠ CVNRADVS · DI · GRA · ROMANORV · REX · III ·

No. 3. ✠ FREDERIC⁹ · DEI · GRA · R OMAN OR · IMPERATOR · AVGS ·

No. 4. ✠ FREDERIC⁹ · DEI · GRATIA · ROMANOR · IMPERATOR · AVGS ·

No. 5. ✠ DEI · GRATIA : ROMANORVM · IMPERATOR · ET · SEMPER · AVGVST⁹ ·

No. 6. ✠ MARIA · DEI · GRACIA · ROMANOR · IMPERATRIX · SEMP · AVGVSTA ·

{72}

SEVEN

Auxiliary Sciences

Sigillography and Diplomatics

HE PRINCE-BISHOP AND HIS AGENTS required familiarity with the new auxiliary sciences of sigillography (the scientific study of seals) and diplomatics (the scientific study of documents) to establish the authenticity of historical documents such as wills and donations. Reference works facilitated this enterprise and served as well for any historical research carried out at the seminary.

{71} Jean Mabillon.
De re diplomatica [*On Diplomatics*].
(Paris: Charles Robustel, 1709).
29.3 cm x 44.6 cm

JEAN MABILLON (1632–1707) was a monk in the Maurist branch of the Benedictine Order, a seventeenth-century monastic movement characterized by its dedication to historical scholarship. The impetus for his composition of *On Diplomatics* was an attack by the Antwerp Jesuit Daniel Papebroche on the authenticity of many old Benedictine documents. Many ancient documents laying claim to land and other sources of revenue and prestige were either outright forged or partially unreliable. This work, originally published in 1681, set forth criteria for assessing the authenticity of historical texts on the basis of features such as material (papyrus, parchment, paper), seal, script, grammar, and style. It is considered the foundational work in diplomatics as well as in paleography (the scientific study of handwriting in manuscripts). The Salzburg Collection copy is a revised second edition published after Mabillon's death by his student Thierry Ruinart.

The book features reproductions of hundreds of documents, two of which are shown here. One is the acts of the 862 Synod of Soissons, complete with the subscriptions of those (primarily bishops and abbots) who attended the meeting (see page 81). The other is

a 653 royal diploma of the Frankish king of Neustria and Burgundy, Clovis II, confirming the liberties of the monastery of St. Denis (see pages 82–83). Clovis's subscription (as "*Chlodovicus rex*") is surrounded by the subscriptions of various witnesses, including many bishops. Mabillon has inserted a note on the bottom right indicating that a seal would have been affixed in that spot.

{71}

NIORIS

[medieval manuscript text, largely illegible]

Post-Pag. 376

Locus Sigilli

TAB. XIII.

{72} Johann Michael Heinecke. *De veteribvs Germanorvm aliarvmqve nationvm sigillis* [*On the Old Seals of the German and other Nations*]. (Frankfurt am Main and Leipzig: Nicolas Foerster, 1709).

22.1 cm x 35.4 cm

ANTIQUARIANS began to study historical seals in the fifteenth century, but it was Mabillon's attention to seals that spurred the beginnings of sigillography. Numerous repertories of historical seals were published during the seventeenth and eighteenth centuries, including a foundational work on the topic by the Lutheran theologian Johann Michael Heinecke (1674–1722). He included dozens of tables showing reproductions of various seals. Two tables are pictured here. Table XIII (page 84 and pages xiv and xv) depicts seals of bishops. The earliest episcopal seals in Europe date from the mid-tenth century; seals became common during the eleventh century, when the archbishops and the cathedral chapter of Salzburg separately adopted the practice of creating and using seals for documentary authentication purposes. Heinecke's repertoire does not include any Salzburg examples. Table VIII (page 78) depicts imperial seals, including the rare seal of Empress Maria of Brabant (reigned 1214–1218), wife of Emperor Otto IV (reigned 1209–1218).

ASTU et LABORE CAPIT CURUS

ROMANORUM

PIETATE et CONSILIO

ROMULUS struxit NUMA FUNDAVIT

EIGHT

Echoes *of* Empire

*The Presence of the Past
in the Salzburg Collection*

N THE COURSE OF THE FOURTH CENTURY, the Roman Empire split into two halves. By the end of the fifth century, the western portion had collapsed, and attempts by the remaining emperors based in Constantinople (such as Justinian) to bring the former western provinces permanently under their control failed. Instead, in 800, Pope Leo III crowned the King of the Franks and Lombards (now known as Charlemagne) emperor. Thereafter, two claimants to the legacy of the ancient Roman Empire co-existed. Successive dynasties controlled the eastern portion, which generally remained centred in Constantinople, until its capture by the Ottoman Empire in 1453. In the west, the dynasty founded by Charlemagne was succeeded by a series of other dynasties, such as the Habsburgs. Throughout, the Roman German or Holy Roman Empire of the German Nation (two contemporary designations for the same set of institutions) was understood to be the direct successor and continuation of the ancient Roman Empire. This perspective is reflected in many of the historical works from the Salzburg Collection, as is often clear from their titles.

{73} Hermann Conring. *Leonis III papae epistolae ad Carolvm Magnvm imperatorem. Capitulare Caroli M. de Villis suis* [*Letters of Pope Leo III to Emperor Charlemagne. The Capitulary of Charlemagne concerning his Villas*] (Helmstedt: Henning Muller, 1655).

15.6 cm x 20.2 cm

CONRING (1606–1681), a professor at the University of Helmstedt, published a series of letters from Pope Leo to Charlemagne written during the lead up to Charlemagne's imperial coronation, followed by Charlemagne's capitulary legislation concerning the administration of his estates. Chapter LXX commanded that the same herbs, fruits, trees, and vegetables be planted in all imperial gardens.

{74} Sebastian Heinrich Penzinger. *Novissimum historiae Quatuor Mundi monarchiarum, Chaldaeorum nempe, Persarum, Graecorum & Romanorum compendium, Gestorum videlicet omnium Imperatorum, a Nimrodo, usque ad Augustissimum Leopoldum, Romanorum & Germanorum Monarcham* [New Compendium of the History of the Four World Monarchies, Namely the Babylonian, Persian, Greek and Roman, and the Deeds of all the Emperors from Nimrod through the Most August Leopold, Ruler of the Romans and Germans]. (Nuremberg: Johann Leonhard Buggel, 1705).

15.7 cm x 20.2 cm

PENZINGER CONSTRUCTS a continuous world history, organized around four successive imperial units, running from Nimrod (an ancient Mesopotamian king mentioned in the biblical books of *Genesis* and *Chronicles*, whose precise regnal dates cannot be identified) to his own sovereign, the Holy Roman Emperor Leopold I (reigned 1658–1705).

{75} Otto Aicher. *Brevis institutio de comitiis veterum Romanorum, libelles tribus comprehensa; Quibus accessit Lib. IV. de Comitijs Imperij Romano-Germanici.* [*A Brief Arrangement concerning the Legislative Assemblies of the Ancient Romans, in Three Books, to which is Appended a Fourth Book concerning the Legislative Assemblies of the Roman-German Empire*]. (Salzburg: Johann Baptist Mayr, 1678).

7.5 cm x 13.4 cm

THIS STUDY, which connected the institutions of the Holy Roman Empire with those of the ancient Romans, was written by a professor at the Benedictine University of Salzburg, founded by Archbishop Paris in 1622.

{76} Casparus Manzius. *Fundamenta urbis et orbis Seu Reipublicae Romanae; Id est tractatus fundamentalis de ortu et progressu Imperii Romani, Ab urbe conditâ, usque ad moderna tempora* [*Foundations of the City and the World, or of the Roman Republic, that is, a Fundamental Tractate on the Rise and Progress of the Roman Empire, from the Foundation of the City through Modern Times*]. (Ingolstadt: Johann Ostermair, 1673). 18.8 cm x 31.2 cm

THIS RANKING of the prelates of the Holy Roman Empire shows that the Archbishop-Electors of Mainz, Trier, and Cologne (in that order) occupied the three highest positions, and that the Archbishop of Salzburg (the papal *Legatus natus*) held the fourth position.

{77} Melchior Adam Pastorius. *Römischer Adler. Oder theatrvm electionis et coronationis Romano-Caesareae* [*The Roman Eagle, Or the Theatre of the Election and Coronation of the Roman Emperors*]. (Frankfurt am Main: Aegidius Vogel, 1657). 15.1 cm x 19.5 cm

IN 1657, Emperor Ferdinand III died without a designated heir, leading to the longest period that the Holy Roman Empire was without an emperor in four centuries. The engraving supports one faction over the other in the struggles concerning who would be elected emperor following Ferdinand's death. Both this book and item 78 were published in Frankfurt am Main, the preferred location for the elections and coronations of Holy Roman Emperors as well as a leading banking, trading, and publishing centre.

{78} Pancratius Lampadius. *Politische Reichs-Händel* [*Political Imperial Matters*]. (Frankfurt am Main: n.p., 1661).

15.4 cm x 20.2 cm

THE ILLUSTRATION depicts the double-headed Imperial Eagle of the Holy Roman Empire and emphasizes the role of the eight princes (including the archbishops of Mainz, Trier, and Cologne) who were designated electors of the Emperor. It was published three years after the election of the new emperor, Leopold I, which ended the interregnum.

{79} Johann Michael Fuchs. *Das Leben Der Bischöff, Ertzbischöff, und Chur-Fürsten zu Cöllen* [*Biography of the Bishops, Archbishops, and Electors of Cologne*]. (Munich: Sebastian Rauch, 1691).

15.8 cm x 21.0 cm

CLAIMS OF LONG HISTORICAL CONTINUITY were not confined to the empire as a general political unit, for historians of other institutions also traced their roots back to antiquity. The opening of Fuchs's collective biography of the prelates of Cologne traces the foundation of the city to the time of Aeneas, and specifically to a refugee from the Trojan War named Colono.

INDEX
Librorum Prohibitor.
BENEDICTI XIV. P.O.M.
jussu editus.

NINE

Controversial Contexts

The Weight of the Present in the Salzburg Collection

HE SALZBURG COLLECTION has several books by best-selling authors, many of whom contributed to the important intellectual debates and political controversies animating early modern Europe. The books listed here are not always the most controversial titles composed by the authors in question, but they nevertheless demonstrate that successive archbishops did not shy away from controversial authors. Many of the authors whose works are in the Salzburg Collection appeared on the papal index of forbidden books.

{80} Sebastian Brant. *Titvlorvm omnivm ivris tam civilis, qvam canonici expositiones* [*Expositions of All the Titles of Civil and Canon Law*]. (Lyons: Sebastian Gryphius, 1553).

11.3 cm x 16.6 cm

SEBASTIAN BRANT (1457–1521) is best known for his satirical *Das Narrenschiff* (*Ship of Fools*) of 1494, criticizing the vices he perceived in the world. In his lifetime, he was most famous for his legal writings.

{81} Heinrich Cornelius Agrippa von Nettesheim. *De incertitvdine et vanitate omnium scientiarum & artium . . . de Nobilitate & praecellentia faeminei sexus . . . de matrimonio* [*On the Uncertainty and Vanity of the Sciences and the Arts . . . On the Nobility and Preeminence of the Female Sex . . . On Matrimony*]. [n.p.: n.p., 1622].

7.5 cm x 12.3 cm

AGRIPPA (1486–1535) threw himself into all sorts of endeavours ranging from the study of occult philosophy to active military service. *On the Nobility and Preeminence of the Female Sex* (1529), dedicated to Margaret of Austria (1480–1530), Duchess of Savoy, Regent of the Netherlands (and former Queen of France), is one of many pro-feminist works composed by European thinkers from around 1400 onwards. Like other feminists of the era, Agrippa argued that women were superior to men.

{82} Jean Bodin. *De repvblica libri sex* [*Six Books of the Republic*]. (Paris: Jacob Dupuys, 1586).

22.6 cm x 35.5 cm

JEAN BODIN (1530–1596) is one of the earliest theorists of the idea of sovereignty, formulated in this best-known work, *Six Books of the Republic* (1576). Bodin was a monarchist who insisted that sovereignty must be absolute, perpetual, and undivided. His theory was intended to establish the independence of sovereign states from claims of overlordship by the Holy Roman Empire and the papacy.

IVSTI LIPSI
MONITA ET EXEMPLA
POLITICA.
LIBRI DVO,
Qui VIRTVTES ET VITIA Principum spectant.

LABORE ET CONSTANTIA

ANTVERPIÆ,
EX OFFICINA PLANTINIANA,
Apud Ioannem Moretum.
M. DC. V.
Cum Priuilegiis Cæsareo & Regio.

{83} Justus Lipsius. *Monita et exempla politica* [*Political Advice and Examples*]. (Antwerp: Plantin-Moretus, 1605).
17.8 cm x 26.0 cm

LIPSIUS (1547–1606) published *Monita* as a sequel to his famous *Politica* of 1589. An important correspondent, translator, and political theorist, Lipsius traversed the religious landscape of early modern Europe, converting from Roman Catholicism to Calvinism and back again. He wrote *Monita* when he was supporting the Catholic Habsburgs in the Low Countries, dedicating this collection of examples of political behaviour to one of the rulers of that territory, the Habsburg archduke Albert. Publishers Christophe Plantin and his son-in-law Jan Moretus were Europe's first industrial-scale printers and, together, a leading supplier of books to supporters of the Counter-Reformation.

{84} Franciscus Johannes Maria Brasichellen. *Index librorum expurgandorum* [*Index of Books to be Expurgated*]. (Stadt am Hof: Johann Gastl, 1745).

10.3 cm x 17.3 cm

BRASICHELLEN (1556–1619)—known by a variety of names including Giovanni Maria Guanzell—was an official of the Roman church who published an *Index of Books to be Expurgated* in 1607, which the Salzburg Collection holds in its 1745, second edition. In 1559, Pope Paul IV had published the first Roman *Index of Prohibited Books*, which was regularly reviewed, corrected, and updated. Brasichellen's approach to censorship was unusual: instead of prohibition, he suggested expurgation and emendation. Shown are his recommendations concerning Jean Bodin's *Method for the Easy Comprehension of History* (1566).

{85} Hugo Grotius. *Drey Bücher vom Rechte des Krieges und des Friedens, darinnen Das Recht der Natur und der Völcker* [*Three Books concerning the Law of War and Peace, including the Law of Nature and International Law*]. (Leipzig: Friedrich Groschuff, 1707).

16.0 cm x 20.5 cm

HUGO DE GROOT (1583–1645), better known as Grotius, was a political theorist from the Netherlands who wrote the original version of this book while a political exile in France during the Thirty Years War (1618–1648). Now considered one of the founders of International Law, Grotius attempted to legitimate claims to authority that did not require recourse to contemporary Christian theologies.

Staats-Kunst/

Auß
Denen selbst-eigenen Worten der heiligen Schrifft gezogen
An
Monseigneur le Dauphin
gerichtet
von

Herrn Jacobo Benigno Bossuet, Bischoffen von MEAUX, Königlichen Staats- und Geheimden Rath/ Ihro Königl. Hoheit des Monseigneur le Dauphin Præceptore, wie auch Ihrer Königlichen Hoheiten der Madame la Dauphine und Madame la Duchesse de Bourgogne Obristen Allmosen-Pfleger.
Ein Werck so erst nach des Authoris Todt zum Vorschein gekommen.
Nunmehr aber auß der Frantzösischen in die Teutsche Sprach übersetzt worden.

STRASBURG/
Verlegts Johann Reinhold Dultzecker/ 1712.

{86} Jacques Bénigne Bossuet. *Staats-Kunst, Auß Denen selbst-eigenen Worten der heiligen Schrifft gezogen* [*Statecraft: Drawn from the Very Words of Scripture*]. (Strasbourg: Johann Reinhold Dulßeker, 1712).
10.7 cm x 18.0 cm

BOSSUET (1627–1704) was a French cleric tied closely to the Bourbon Dynasty. He composed much of this tract while employed as tutor to the royal heir during the 1670s. It was published in 1709, after his death, with additional materials not of his composition. The Salzburg Collection contains a 1712 German translation published in Strasbourg, a one-time Imperial Free City of the Holy Roman Empire annexed to France in 1681.

{87} Hermann Friedrich Brauns. *Nodvs gordivs aenigmatis sibyllini de nomine dei…solvtvs* [*The Gordian Knot of the Sibylline Riddle on the Name of God…Solved*]. (Leipzig: Wolffgang Deer, 1728).

15.2 cm x 19.5 cm

THE "SIBYLLINE ORACLES" were a series of early Christian forgeries designed to demonstrate that the Greek Sibyls, like the Hebrew Prophets, had foretold the coming of Christ. They included a famous riddle on the name of God that came to be known as the "Gordian Knot." Many scholars attempted to solve the riddle, including Brauns, a priest of Magdeburg. In order to do so, he employed multiple esoteric strategies, such as assigning numerical value to letters of different alphabets. Shown here are his musings on the magic incantation "Abracadabra."

{88} Pope Benedict XIV. *Index librorum prohibitorum* [*Index of Prohibited Books*]. (Rome: Camera Apostolica, 1758).

10.8 cm x 17.3 cm

GIVING NEW FORCE to censorship was a central concern of Pope Benedict XIV (reigned 1740–1758), who personally supervised a major and thorough revision of the papal index of prohibited books. At the end of the process, few books were removed and many new books were added. Benedict's index runs to over 300 pages and includes works by Agrippa (item 81), Bodin (item 82), Lipsius (item 83), and Grotius (item 85).

Institutionum Juris
prudentiæ Publicæ
universæ Liber I.
De
Jure Publico in Genere.

TEN

Binding Fragments

Book Covers in the Salzburg Collection

MEDIEVAL MANUSCRIPTS and other textual fragments were sometimes used for binding printed books. Medieval manuscripts were slated for dismemberment and re-purposing for various reasons including, but not limited to, the following: they were no longer easily legible due to changes in scripts; their contents were no longer relevant due to changes in practice (for instance in the liturgy); they were heavily damaged due to extensive prior use. Techniques of reuse ranged from cutting parchment manuscripts into multiple thin strips to reinforce a new binding, to covering an entire book in large leaves from an older manuscript. Examples of various ways in which binding fragments were reused can be found in the Salzburg Collection.

When representatives of the Hill Monastic Manuscript Library (Collegeville, Minnesota, USA) microfilmed the medieval manuscripts in the seminary library in 1968, they found a cache of loose leaves presumably intended for use as binding fragments. Although it has not been possible to view the microfilms of the loose manuscript leaves in order to be certain, from their general description, it seems as if some of the leaves that still remained in the seminary library were taken from the same medieval manuscripts that had previously been used to bind some of the books that were sold to the University of Alberta in 1965.

{89} Breviary Fragment

15.2 cm x 19.2 cm

HERE A SERIES OF PAMPHLETS by Johann Frischmann (1612–1680) on aspects of the election and installation of emperors, all published in 1657 and 1658, are bound together with a bi-folium from the sanctoral section of a (probably) thirteenth-century breviary. This (trimmed) fragment shows portions of the readings used for the liturgical celebration of three widely celebrated feasts: St. Juliana (February 16), the Chair of St. Peter in Antioch (February 22), and St. Gregory the Great (March 12).

[Medieval manuscript fragment in Latin, written in Gothic script with red rubrics and decorated initials. Transcription not attempted due to heavy abbreviation and specialized paleographic content.]

{90} Offset

9.8 cm x 17.3 cm

HERE, TWO BOOKS PUBLISHED in Frankfurt am Main in 1625 and 1647, respectively, are bound together with an offset from a Latin translation of an originally Greek homily by Archbishop of Constantinople John Chrysostom (c.349–407). At one point, a sheet of parchment from a manuscript copy of the text was glued to the binding holding together the two books. When someone pulled off the manuscript, much of the ink from the side of the parchment that had been glued down remained on the exposed book cover. The writing that remains (known as an offset) is reversed and can be deciphered with the aid of a mirror.

{91} *Vocabularius utriusque juris* [*Dictionary of Canon and Civil Law*]. (Lyons: Benedict Bonnyn, 1537).

12.4 cm x 18.9 cm

THIS BASIC LEGAL DICTIONARY was used to such an extent that it is falling apart and now normally stored inside a special protective box. At some earlier point, someone reinforced the fragile binding of this practical reference work by inserting a leaf from a medieval manuscript. The Latin text, which contains translated quotations from the biblical books of Jeremiah and Leviticus, could not be identified by the curators.

{92, 93, 94}

Medieval Music

THREE SEPARATE COLLECTIONS of smaller works on the constitutional law of the Empire, all published between 1632 and 1642, are bound in fragments from musical manuscripts (see pages 108, 114 and 115). The script used for the texts, the notational style used for the music (neumes), and other aspects of the manuscripts (such as decorative elements) indicate that they were produced somewhere in Austrian or Czech lands in the later decades of the fifteenth century. Although all three fragments are clearly drawn from (two separate) manuscripts of medieval liturgical chant, only one of the binding fragments (item 94) shows enough text to identify the specific chant in question: the hymn introit used, in the traditional Latin liturgy, for the Second Sunday of Advent ("Populus Syon").

{92} {93} {94}

Binding Fragments ∞ *Book Covers in the Salzburg Collection* 115

{92} 16.3 cm x 21.5 cm

{94} 14.6 cm x 20.0 cm

{95} Alessandro Tartagni. *Super prima infortiati parte* [*On the First Part of the Infortiatum*]. (Milan: Leonard Pachel, 1488).
27.9 cm x 39.3 cm

TARTAGNI'S COMMENTARY on the *Infortiatum* (the term used by jurists to designate the second part of Justinian's *Digest*) was the first book ever printed by Pachel (1451–1512) as a sole printer. A Bavarian, Pachel was training as a printer in Milan from the very beginnings of the industry there around 1470. Between 1477 and 1487, he collaborated in a print shop with Uldericus Scinzenzeler. In 1488, he struck out on his own, remaining active until 1511 and becoming one of the most prolific printers of the incunabulum era. However, the printing process on the 1488 Tartagni was never completed; for instance, the large initials intended to mark the beginning of each section of the text were never added.

The binding of this incunabulum (which may not have been done by Pachel himself, but rather by a specialized binder) was created from reused elements. Multiple loose sheets of previously-used paper (some printed, some handwritten) were pressed and glued together to form two boards and then covered with black printer's ink. The whole is held together with (visible) hemp or flax straps, and the spine alone is covered with leather. The top layers of the black-washed board reach all the way to the edge of the leather spine binding on only one side of the book.

Archi-Episcopalis Collegii Sa-
lisburgensis Presbyterorum
& Alumnorum.

Fieri non potest, ut quisquam uere
probus sine prudentia iudicet

Franciscus Schmidt.

XXI J. 23.

huius pleniſſimum argumentum.
...guinitatis τ affinitatis arboꝛ ūtic impꝛimtt. fo. ccccxxv.
...tiones domini Archidiaconi reperiuntur.
...untur biblie capita caractere textuali impꝛeſſa.
...gna... rabula pro gloſarum medullis in marginibus poſitis,
...rie... andorum congregatio ſub indice fideliſſimo.
...aria... mina totam bꝛeuiter materiam complectentia.
...neſt... erum abbꝛeuiarum enigmata ſuccincte reſoluens.
...eorſum concilia ſunt hic diuerſis ex locis coadunata.

Aſtic ſi notulas vis ſuſpectare pꝛioꝛes.
Coꝛrectoꝛis habes docti cognomen apertum.

Decretum aureum domini
Gꝛatiani cuꝫ ſuo apparatu.

Franciscus Schmidt J.V.D. Aqi.

SELECT BIBLIOGRAPHY

Agrippa von Nettesheim, Heinrich Cornelius, *Declamation On the Nobility and Preeminence of the Female Sex*. Trans. Albert Rabil (Chicago: University of Chicago Press, 1996).

"Archbishop of Salzburg's Library," https://bpsc.library.ualberta.ca/collections/archbishop-of-salzburgs-library [Accessed March 4, 2017.]

Banski, Erika and Louis-Mathieu Paquin, "The Salzburg Collection at the University of Alberta Libaries," PowerPoint Presentation, 2007. https://web.archive.org/web/20110930211135/http://repository.library.ualberta.ca/salzburg/contact.html [Accessed March 4, 2017.]

Bodin, Jean. *On Sovereignty: Four Chapters from* The Six Books of the Commonwealth (Cambridge: Cambridge University Press, 1992).

Bossuet, Jacques-Bénigne. *Politics Drawn from the Very Words of Holy Scripture.* (Cambridge: Cambridge University Press, 1999).

Donato, Maria Pia. "Reorder and Restore: Benedict XIV, the Index, and the Holy Office" in *Benedict XIV and the Enlightenment: Art, Science and Spirituality* ed. Rebecca Messbarger et.al. (Toronto: University of Toronto Press, 2016). 227–252.

Dopsch, Heinz and Hans Spatzenegger. *Geschichte Salzburgs: Stadt und Land*. Vols. 1 and 2. (Salzburg: Pustet, 1991).

Dotson, Esther Gordon. *J.B. Fischer von Erlach: Architecture as Theater in the Baroque Era.* (London: Yale Univ. Press, 2012).

Gratian. *The Treatise on Laws with the Ordinary Gloss.* (Washington, DC: Catholic University of America Press, 1993).

Grotius, Hugo. *Rights of War and Peace.* 3 vols. (Indianapolis, IN: Liberty Fund, 2005).

Hartmann Wilfried and Kenneth Pennington, eds. *The History of Medieval Canon Law in the Classical Period, 1140–1234: From Gratian to the Decretals of Pope Gregory IX* (Washington DC: Catholic University of America Press, 2008).

Hauc, Jean-Claude. *Ange Goudar. Un aventurier des Lumières* (Paris, 2004).

Helsen, Kate. "The Evolution of Neumes into Square Notation in Chant Manuscripts" *Journal of the Alamire Foundation* 5 (2013): 143–174.

Lightfoot, J.L. *The Sibylline Oracles.* (Oxford: Oxford University Press, 2007).

Milway, Michael. "Forgotten Best Sellers from the Dawn of the Reformation" in Robert J. Bas and Andrew Gow, eds. *Continuity and Change. The Harvest of Late Medieval and Reformation History* (Leiden: Brill, 2000). 113–142.

Probszt, Günther. *Die Münzen Salzburgs*. 2. Ed. (Graz: Akadem. Druck- u. Verlagsanstalt., 1975).

"The Salzburg Collection," Bruce Peel Special Collections Library, *Square Old Yellow Books: Aspects of the Bruce Peel Special Collections Library*. (Edmonton: Bruce Peel Special Collections Library and Department of Art and Design, University of Alberta, 1993). 36–43.

Schliessleder, Wilhelm. *Die Bibliothek des Erzb. Priesterseminars zu Salzburg*. (Salzburg: n.p., typescript, 1955).

Schremmer, Eckart. "Saltmining and the Salt-trade: A State-Monopoly in the XVIth – XVIIth Centuries. A Case-Study in Public Enterprise and Development in Austria and the South German States," *Journal of European Economic History* 8:2 (1979): 291–312.

Schroeder, H.J., trans. *Canons and Decrees of the Council of Trent*. (Rockford, IL: TAN Books, 2005).

Strauss, Felix F. "A Sixteenth-Century Sketch of Gold Mining Installations in Salzburg," *Historian* 22:2 (1960): 119–128.

Szabo, Franz A.J. *Legacy of Empire: Treasures of the University of Alberta's Central European Library Collection: Exhibition and Catalog*. (Edmonton: University of Alberta Libraries, 2008).

Tietze, Christoph. *Hymn Introits for the Liturgical Year* (Chicago: Hillenbrand, 2005).

Widmann, Hans. *Geschichte Salzburgs*. Vol. 3: *1519–1805*. (Gotha: Friedrich Andreas Perthes, 1914).

Wilson, Peter C. *The Holy Roman Empire, 1495–1806*. 2nd ed. (NY: Palgrave, 2011).

Winroth, Anders, *The Making of Gratian's Decretum* (Cambridge: Cambridge University Press, 2000).

Yates, Donald. *Descriptive Inventories of Manuscripts Microfilmed for the Hill Monastic Library. Austrian Libraries* vol. 1 (Collegeville, Minnesota: Hill Monastic Manuscript Library, 1981).

Zeeden, Ernst Walter, "Salzburg," Anton Schindling and Walter Ziegler, eds., *Die Territorien des Reichs im Zeitalter der Reformation und Konfessionalisierun: Land und Konfession 1500–1650*, Vol. 1: *Der Südosten*. (Münster: Aschendorff, 1989). 73–85.

ABOUT THE AUTHORS

FELICE LIFSHITZ is Professor of Women's and Gender Studies, and of Religious Studies, at the University of Alberta. Her research and teaching concentrate on the cultural landscapes of the pre-modern world, with particular attention to religious texts and practices, above all in Medieval Europe. Her publications include *Religious Women in Early Carolingian Francia: A Study of Manuscript Transmission and Monastic Culture* (2014), *The Name of the Saint: The Martyrology of Jerome and Access to the Sacred in Francia (627–827)* (2005), and *The Norman Conquest of Pious Neustria: Historiographic Discourse and Saintly Relics (684–1090)* (1995). Her current research concentrates on the representation of the European Middle Ages in historical films.

JOSEPH F. PATROUCH is the Director of the Wirth Institute for Austrian and Central European Studies and a Professor in the Department of History and Classics at the University of Alberta. His research and teaching concentrates on the histories of Central Europe, the Holy Roman Empire, and the possessions of the Habsburg Dynasty in the Early Modern Period (c.1400–1800). His publications include *Queen's Apprentice: Archduchess Elizabeth, Empress María, the Habsburgs and the Holy Roman Empire, 1554–1569* (2010) and *A Negotiated Settlement: The Counter-Reformation in Upper Austria under the Habsburgs* (2000). Professor Patrouch's current research concentrates on the imagined landscapes of the Holy Roman Empire around 1570.

WIRTH INSTITUTE FOR AUSTRIAN AND CENTRAL EUROPEAN STUDIES

THE WIRTH INSTITUTE FOR AUSTRIAN AND CENTRAL EUROPEAN STUDIES is the only university institute in Canada that devotes itself exclusively to the interdisciplinary study and understanding of Central European subject matter. Established in 1998, the Wirth Institute acts as both an academic and cultural institute. It sponsors and organizes symposia, lectures, exhibitions, conferences, concerts, artistic festivals, and other scholarly and cultural events with Austrian and central European themes.

Renamed in October 2003 in recognition of Dr Manfred and Dr Alfred Wirth's generous endowment, the Institute's mandate is to raise the profile of Central Europe and Central European Studies in Canada and to provide a leadership role in this field in a network of Canadian universities. The Institute is part of a worldwide network of similar institutes and has partners in six countries. It works with the Embassies of Austria, Croatia, the Czech Republic, Hungary, Poland, Slovakia, and Slovenia to maintain and enhance its reputation as Canada's most outstanding resource centre for Central European Studies.

ABOUT THE SALZBURG COLLECTION

THE UNIVERSITY OF ALBERTA LIBRARIES' SALZBURG COLLECTION comprises 3,500 volumes (published 1488–1960s) from the original law collection of the Archbishop of Salzburg's Seminary Library, founded in 1579. Approximately half of the books in the Salzburg Collection (generally items published prior to 1800) are housed in Bruce Peel Special Collections, while the other half are dispersed, by subject, among other University of Alberta Libraries. The Salzburg Collection contains important source materials and a wealth of secondary literature pertaining to law. Its emphasis is canon law, but it covers all aspects of law—canon, civil, commercial, constitutional, and criminal—as well as jurisprudence and history of law. Also included are books documenting the history, politics, and culture of the Austro-Hungarian Empire, the Holy Roman Empire, and other European countries, regions, and societies over several centuries. A link to the collection finding aid is available on the "Research Collections" page of the Bruce Peel Special Collections website: bpsc.library.ualberta.ca

MAIN BODY set in Bembo Std regular, italic, and small caps,
with heads, subheads, and page numbers set in
Akzidenz-Grotesk Std. Printed in four-colour process
on Cougar Opaque 100 lb. text and cover
by Burke Group in Edmonton, Alberta.

The accent colours of red and blue that are used in this
catalogue design are drawn directly from the printed works
and manuscript bindings in the Salzburg collection.
A generous use of white space on the pages makes reference
to salt, the natural resource that strengthened the economic
power of the prince-bishops.